About the Authors

Ron Cordes　　　**Gary LaFontaine**　　　**Mary Mather**

Ron Cordes and Gary LaFontaine created the Pocket
Guide concept. Mary Mather is a professional nature
photographer and active outdoors person whose
world-wide experiences formed the basis for this book.

Other Pocket Guides Available
For Retail Orders Call 1-800-874-4171

Lake Fly Fishing	Fly Fishing	Outdoor Survival
Dry Fly Fishing	First Aid	Target Archery
Nymph Fishing	Canoeing	Fly Fishing Knots
Steelhead Fly Fishing		Saltwater Fly Fishing

Hiking / Backpacking

Artwork by Kirk Botero

ISBN 0-9633024-5-0

P9-CJY-376

D0420124

$12.95

SKIING / SNOWMOBILING

Key Issues ➤

- Maximize photographic versatility but minimize weight.
- Quick access to equipment.
- Protect equipment from cold, snow and impact.

Equipment

Camera	Wide Angle Lens	Batteries
Filters	Medium Telephoto	Film
Lens Cleaner	Padded camera pack	
Chest Harness	Dry Cloth	Large Plastic Bag

Key Technique 1 ➤ Use chest harness to carry camera comfortably and for quick access. Keep camera under outer layer of clothing to keep it warm. Carry extra camera batteries and film in inside pockets.

Key Technique 2 ➤ Meter for **snow scenes** by using a gray card or take a meter reading off of snow or ice and open lens one f-stop, or decrease shutter speed one stop.

Key Technique 3 ➤ Meter for **people** by moving in close to get reading off of face.

Key Technique 4 ➤ Protect your equipment from condensation by placing it in a camera case or plastic bag before going indoors. Leave in bag for 30 minutes.

BOATING

Best time of day: Early morning and evening for warm light or whenever action occurs.

Best Lighting: Front lighting

Lenses: Wide angle to medium telephoto

Film: ISO/ASA 200 or faster when taking pictures from a boat to avoid blurred shots.

Shutter Speed: 1/500 or faster to counteract movement of the boat and freeze the action of a water skier, sailboat, windsurfer, other boats.

Aperture: f-8 to f-16 for scenics, f/4 to f/5.6 to isolate moving subject and increase shutter speed.

Focus

- For moving subjects, use pre-focus or panning technique as described under the "Action" section of this Guide.

- With autofocus cameras, set to "continuous focus" and take picture when subject reaches a desired area or range.

- If photographing from a moving boat, or if camera does not have a continuous focus, put camera in manual focus mode.

Keep camera equipment accessible but dry in waterproof packs or plastic bags.

FISHING

Key Technique 1 ➤ Use **pre-set technique** to allow the photographer to frame his subject as it moves about, without continually refocusing. Of particular value if photographing fisherman with jumping fish.

- Use a 80-200 or 43-86 mm zoom lens with depth of field scale lines
- Preset the shutter speed and f-stop to maximize the area in focus:

Step 1: Select a fast shutter speed (1/250 sec)
Step 2: Take light reading to identify f-stop
Step 3: Set infinity symbol on distance scale of lens on focusing ring to the left depth of field line corresponding to your f-stop.
Step 4: Zoom in and out to frame your subject as needed and take photo when appropriate. (Caution:If your lens does not have such lines, use as small an f-stop as possible, prefocus on the fisherman, and zoom as needed)

Key Technique 2 ➤ Use **chest harness** to carry camera comfortably and for quick access (cover with plastic bag to protect from water).

Key Technique 3 ➤ Use **polarizing filter** to eliminate glare from fish and water and to saturate the colors of the fish and water.

Key Technique 4 ➤ For **portrait of fisherman** with his fish, use same lens but focus on edge of fish or eyes of fisherman.

HIKING & BIKING

Key Issues ➤

- Maximize photographic versatility but minimize weight.
- Quick access to equipment.
- Equipment must be protected from dirt, water, and impact.

Equipment

Camera	Wide Angle Lens	Batteries
Filters	Medium Telephoto	Lens Cleaner
Chest Harness		Monopod
Closeup Equipment		

Film

- 3 rolls per day, 36 exposures.
- 200 ASA/ISO to allow all photographic situations to be met without added weight.

Storing Equipment

- Protect equipment from dirt, heat, sun, rain, and vibration by carrying it in a padded backpack, fannypack, or vest when hiking.
- Use padded saddle bags or hard-sided bags and packs with padding when bicycling.
- Use a **chest harness** to hold camera against body when not in use but for quick access.
- Pack equipment so it is easily accessible.
- Be prepared for any kind of weather.

FLASH TECHNIQUES

When To Use Flash Outdoors

- To eliminate harsh shadows that create too much contrast by filling dark areas with light.
- To freeze action of close fast-moving subjects.
- To photograph nocturnal animals.

People

For automatic flash units ➤

- Set camera to proper flash-sync shutter speed, ranging from 1/250 to 1/60 second.
- Take a meter reading of sunlit area on person's face or sky if subject is backlit, and set aperture to give correct exposure of that area.
- On the flash calculator chart, find the distance that corresponds to an aperture one stop larger than you set in Step 2 above. Example: if you select an aperture of f-16, find the distance that corresponds to f-11.
- Stand at this distance from your subject to take the picture. A zoom lens will allow adjustment of image size.
- Set flash to manual and take the picture.

TTL flash units will automatically take a meter reading "through the lens" off of a person's face to give proper exposure.

EXPOSURE

The Three Exposure Controls
● Film Speed ● Aperture ● Shutter Speed

Shutter Speed
Shutter speed controls the length of time the film is exposed to light. Shutter speeds generally range from 1/4 - 1/2000 of a second. The B setting can be used to make time exposures: the shutter stays open as long as you press the shutter release. A shutter speed of 1/125 of a second is twice as fast as 1/60 of a second; so half as much light reaches the film. Changing from 1/60 to 1/30 allows twice the light to reach the film. High shutter speeds (1/125 & faster) freeze a moving subject.

Aperture
The aperture (f-stop) controls the amount of light that comes in through the lens. F-stops range from f-1.4 to f-32, depending on the lens. The higher the number, the smaller the lens opening and the less light coming in through the lens. As you move from the largest f-1.4, to the smallest aperture f-32, each step decreases the amount of light entering the lens by half, and as you move in the opposite direction, it doubles.

f/2 f/2.8 f/4 f/5.6 f/8 f/11 f/16

EXPOSURE

Film Speed

Film speed (ISO/ASA) is a measure of a film's sensitivity to light. The higher the ISO/ASA number, the less light you will need to record the picture on film.

- **High speed films** (ISO 400 to 1000) are best used in low lighting conditions, to stop action, or when handholding a long lens.
- **Slower speed films** (ISO 25 to 200) need more light but have less grain providing you with sharper pictures.
- When **film speed is doubled** the exposure required for a certain scene is cut in half.

Bracketing

Key Strategy: Bracket your shot to ensure that at least one of several photos of the same subject will be properly exposed.

- **Procedure:** To bracket your exposure, take one picture at the setting suggested by the camera meter, a second exposure at 1/2 to one stop overexposed (i.e., smaller numbered f-stop or longer shutter speed), and a third exposure at 1/2 to one stop underexposed (i.e., larger numbered f-stop or faster shutter speed).

Caution

This is especially important when using slide film.

TYPE OF LIGHTING

Front Lighting

Front lighting is light that is coming in from behind the camera. Front lighting highlights details and saturates colors in a scene, but it flattens the form of a subject unless the light is soft.

Side Lighting

Side lighting emphasizes depth, dimension, and texture of a subject. The long shadows from side lighting help to clarify relationships between objects and emphasize form and mass.

Back Lighting

Back lighting creates silhouettes of solid objects and accentuates texture and form. For silhouettes, meter the light near (but not including) the sun, set exposure for that reading, focus on subject, push shutter button. To expose for foreground subject, take exposure reading off of subject, set camera for that reading, move back and take picture.

Overcast

On overcast days the light is spread evenly over a subject softening both form and texture. Contrast is low, colors saturated.

CHOICE OF FILM

Slides

- Appropriate for presentations, in particular with large audiences.
- Can still make prints from slides if necessary.

Prints

- Print film has more exposure latitude than slide film.
- If your prints appear 1-2 stops over exposed (too light) or under exposed (too dark) , you can have a print made lighter, darker, warmer etc. by the processing lab. This cannot be done with slides.

Metering Techniques

Bright subjects ➤ Snow, beaches, flowers, waterfalls, some wildlife. Open lens 1 to 1 1/2 stops from indicated value, or decrease shutter speed, if majority of subject in viewfinder is bright. Otherwise, whites may appear gray in final photograph.

Dark subjects ➤ Rocks, water, some wildlife, shadows. Close lens by 1 to 1 1/2 stops from indicated value, or increase shutter speed, if majority of subject in viewfinder is dark. Otherwise, subject may appear too light in final photograph.

A gray card, green grass, faded jeans, or a dirt road can be used to establish an average meter reading.

FILM

FILTERS

Skylight / UV Filter

Skylight and UV filters are used to protect the lens from dirt, blowing sand, mist, scratches and fingerprints. They can minimize the effects of haze but are not as effective as the polarizing filter for this purpose.

Polarizers

Polarizers, which must be aimed at right angle to the sun, are used for the following reasons:

- Eliminate glare from non-metallic reflective surfaces, i.e. water, rocks, leaves and glass.
- Darken blue skies.

Procedure: Attach it to the lens and rotate it until unwanted reflections and glare are minimized or the sky turns a darker blue.

Warming Filter

Warming filters such as 81A, 81B, 81C are light balancing filters that are used to . . .

- Provide a warmer tone to a scene.
- Correct the tendency toward bluish tones.

Neutral Density Filter (ND)

Neutral density filters are used to control the amount of light entering the camera lens for the following three reasons . . .

- To deliberately reduce light
- To use slower shutter speeds or wider apertures
- To decrease depth of field

COMPOSING THE PICTURE

Rule of Thirds

Purpose: Application of the Rule of Thirds often makes the composition of a picture more pleasing.

Procedure: Place the subject off center where the horizontal lines intersect either the left or the right vertical line. Place the horizon in the upper or lower 2/3's of the frame as appropriate.

Alternate Perspectives

Purpose of Changing Perspective: To create a more unique and interesting picture.

Changing Perspective: The apparent perspective can be altered by either shooting from different angles and/or by changing lenses.

COMPOSE

SCENIC PHOTO TECHNIQUES
Four Key Considerations

- Lighting
- Lens Choice
- Composition
- Depth Of Field

Meadows

Best Lighting: Side, front, and back lighting
Best Time of day: Early morning and evening
Lens choice: Wide angle to medium telephoto
Composition: See rule of thirds. Tip camera down to include foreground when using wide angle lenses to give depth to your picture.
Depth of field: Move in close. Use f-8 to f-16 to give maximum sharpness from background to foreground.

Mountains

Best Lighting: Side lighting, back lighting
Best Time of day: Early morning & evening
Lens choice: Wide angle when close to mountains or to include foreground. Telephoto when at a distance or to shoot mountain tops.
Composition: Place mountains in upper third of frame to make them look like mountains, not molehills.
Depth of field: f-8 to f-16 for maximum sharpness when foreground included; f-5.6 to f-8 for mountain tops.

SCENIC PHOTO TECHNIQUES

Canyons

Best Lighting: Side lighting, back lighting
Best Time of day: Early morning and evening
Lens choice: Wide angle to medium telephoto
Filter: Polarizing filter to remove haze
Composition: Tip camera down and place the rim of the canyon in the upper third of the frame to make the canyon appear wide and deep. Zoom in and fill the frame with individual plateaus, hoodoos, etc.
Depth of Field: f-8 to f-16 for maximum sharpness when foreground included; f-5.6 to f-8 for individual plateaus and hoodoos.

Seascapes

Best Lighting: Side, front, and back lighting
Best Time of day: Early morning and evening
Lens choice: Wide angle to medium telephoto
Filter: Polarizing filter to remove glare/haze
Composition: Important to keep horizon line straight. Tip camera down to emphasize beach and water; tip up for sky. Boats, lighthouses off-center to right or left side of frame.
Depth of Field: f-8 to f-16
Shutter Speed: 1/125 to 1/250 of a second to stop the action of the waves; 1/15 of a second or slower using tripod to blur the waves.

SCENIC PHOTO TECHNIQUES

Waterfalls

Best Lighting: Front lighting, side lighting, back lighting. (Even good in overcast!)

Best Time of day: Early morning and evening (Check to see when the falls will be illuminated by the preferred lighting.)

Lens choice: Wide angle to telephoto

Filter: Polarizing filter to remove glare

Composition: Fill the frame with falls. Allow space above / below falls to show river. Place top of falls in upper third of frame to show its height. Use the river/stream as a leading line to the falls in the lower section of the frame.

Shutter Speed: 1/125 to 1/250 of a second to stop the action of the water; 1/15 of a second or lower to blur the water.

Streams

Best Lighting: Side lighting, back lighting

Best Time of day: Early morning for mist; evening for warm light & shadows. Overcast days great for rich colors, especially in the fall.

Lens choice: Wide angle to medium telephoto

Filter: Polarizing filter to remove glare

Composition: Photograph area of the stream that curves to make the picture more inviting.

Depth of Field: f-8 to f-16

Shutter Speed: 1/125 to 1/250 sec to stop the action of the stream; 1/15 to blur action.

SKY TECHNIQUES

Sunrise / Sunset

How to meter: Take a meter reading of sky to right or left of the sun. Do not include the sun in the viewfinder. Set your exposure for this reading and photograph the scene.

Composition: Place a person, tree, cactus, etc. in the foreground to frame the scene. Sun should be in right or left third of the frame.

Lens choice: Wide angle for panoramic; 200-400 mm to make the sun appear larger.

Filter: 81A or 81B to to add additional warmth (i.e., adds more redness).

Clouds

Lens choice: Wide angle for panoramic; telephoto for individual cloud formations.

Filter: Polarizing filter to darken blue skies and accentuate clouds. Graduated neutral density filter to darken the sky without affecting the landscape.

Exposure: Set exposure for blue sky or gray storm clouds.

Rainbows

How to meter: Set exposure for bright area surounding rainbow. Bracket or underexpose 1/2 to 1 stop if using slide film.

Filter: Polarizer to intensify colors. Rainbow may disappear if the filter is not used properly.

WILDLIFE

Technique

Best Lighting: Side lighting, back lighting, front lighting, and overcast days

Lenses: 200 mm to 600 mm

Tripod: Tripod or gunstock must be used for 300 mm lenses or larger for sharpest pictures.

Shutter Speed: 1/125 sec or faster to stop the motion of animals; 1/250 sec or faster for animals running, barking, bugling, etc. If hand-holding the camera, shutter speed should match the focal length of the lens (i.e. 200 mm lens at 1/250 sec) for sharp pictures.

Aperture: Depends on shutter speed and composition. For individual animals use f-2 to f-16. For more than one animal in the same scene use f-8 to f-16.

Suggested Exposures for bright sunny days using ISO 100 speed film for middletone, for dark, and for white animals

Middletone	Dark	White
1/500 f/8	1/500 f/5.6	1/500 f/11

Film: High Speed - ISO 200 or above.

Focus: Focus on the eyes of the animal.

Composition: Use the **Rule of Thirds** placing subject off center. To capture animals full frame, allow space in 1/3 of the frame in front of the head to give them room to walk or run.

WILDLIFE

Birds

Best places: Rookeries, ponds, lakes, rivers. Look for trees including dead trees.
Best Lighting: Early in the morning and late in the afternoon when light is soft and birds more active.
Lenses: 200 to 600 mm
Tripod or gunstock: A must for 300 mm lenses or larger for sharpest pictures.
Blind or remote control: A blind or remote cable release should be used to photograph birds in a nest or strutting grouse etc., so as not to disturb the birds.

Birds in nest or on the ground
Focus: On the eyes
Shutter Speed: 1/125 sec or faster

Birds in flight
The best time to capture a bird in flight is at take off or landing.
Focus: Preset the focus on nest, limb, or bird itself, then push the shutter button on take off. Follow bird **in flight** with camera, preset focus or set auto-focus lens on continuous focus: when the bird appears to be in focus, push the shutter button.
Shutter Speed: 1/250 sec or faster

SLR CAMERAS

Manual Camera - Through The Lens Meter

- Photographer manually chooses aperture (f/stop) and shutter speed for correct exposure.

Fully Automatic Camera

- Camera chooses aperture and shutter speed. No changes in exposure can be made.

Automatic With Manual Override

- **Aperture priority:** Photographer chooses f-stop, camera chooses shutter speed.
- **Shutter priority:** Photographer chooses shutter speed, camera chooses f/stop.
- **Manual mode:** Photographer can choose to override choice of f/stop and/or shutter speed made by camera.
- **Program mode:** Camera selects both f/stop and shutter speed.

Auto-Focus Cameras

- The **metering** system can be fully automatic or automatic with manual override. Auto-focus cameras provide fast focusing for still and action subjects. (See " focus" for additional discussion.)

LENS CHOICES

Macro Lenses: 55, 100 mm

- Close-ups of flowers, insects, small mammals
- 55 mm lens for scenics
- 100 mm portraits of people

Wide-Angle Lenses: 24, 28, 35 mm

- Scenics: mountains, canyons, farms, meadows, waterfalls, forests, architecture.
- May cause distortion (subjects may appear to lean to one side if you are too close).

Standard Telephoto Zoom: 28-70 mm

- Frame subjects as with fixed focal length wide-angle lenses.

Medium Telephoto Zoom: 80-200 mm

- Wildlife, scenics, action/sports, close-ups. Most zoom lenses have a "macro mode."

Telephoto Lenses: 300, 400, 600 mm

- Wildlife, sports, action. A tripod, gunstock or other support must be used to avoid camera motion.

ACTION

To **freeze** a moving subject, select the fastest shutter speed that will still permit proper exposure. Prefocus on the area where the peak action will occur. Wait for the subject to reach that point and press the shutter button.

Panning enables you to use a relatively low shutter speed (1/15 - 1/30 sec) to stop action, while creating background blur. Prefocus on the area where you want to take the picture, follow the subject in your viewfinder until it reaches the desired spot, gently squeeze the shutter button and continue to follow through.

People In Action

Composition ➤ Leave space within boundary of the frame for subjects to "move".

Subject	Shutter Speed
Bicycling - medium speed	1/250 second
Bicycling - fast speed	1/500 second
Cross-country skier	1/125 second
Downhill skier	1/500 second
Fisherman casting	1/250 second
Hiker	1/125 second
Running children	1/250 second
Sailboats	1/250 second
Speedboats	1/1000 second
Water skier	1/500 second

FOCUS

Auto-Focus

Autofocus cameras are usually designed to focus on a subject in the center of the focusing screen. To place your subject off center, focus on your subject (place subject within focusing brackets), push shutter button down half-way to lock in focus, recompose and continue to push the shutter button to take picture. When photographing subjects of low contrast such as waterfalls, fog, or clouds, use manual focus because low contrast makes it difficult for your lens to focus. **For fast moving subjects, set camera/lens to continuous focus (if available) or pre-focus on an area and set on manual focus. (See "Action" section.)**

Selective Focus

The range of sharp focus in a photograph is called the **depth of field.** Depth of field is controlled by:

- **Aperture or f-stops:** A higher number f-stop will put more of your picture in focus.
- **Focal length of the lens:** The longer the lens, the more limited the depth of field. If you need more depth of field, increase your f-stop and/or use a shorter focal length lens.
- **Subject distance:** With the same f-stop, the closer the camera is to the subject, the more limited the depth of field.

SKY TECHNIQUES

Lightning

For Nighttime Shots
Aperture: f-5.6

For Daytime shots
Aperture:	
f-5.6	ISO 64-100
f-8	ISO 125-200
f-11	ISO 200-400

Shutter Speed: Open shutter to "B" setting and leave open for several minutes or until a number of lightning bolts have flashed across the sky. (Use both daytime and nighttime)

Cable Release/Tripod: Use cable release and tripod for both day & night lightning shots.

Focus: Infinity

Moonlit Scene

Best Time: Twilight. Note that first half hour after sunset allows for good exposure of both land and sky.

Meter reading: Meter to the left or right of the moon (excluding the moon) and set your exposure (f stop and shutter speed) manually. Recompose and shoot.

Bracket exposure: To ensure at least one good photo, use the bracket technique.

Caution: Exposures longer than 1/8 of a second will cause the moon to look elongated.

WILDLIFE

Where to Find Wildlife

- Knowledge of your subject will get you to the right place at the right time, and enable you to predict an animal's behavior.

- Most animals graze in open areas in early morning and early evening. They retreat to the woods to avoid heat, bugs, predators, and wind at other times during the day.

- Look for fresh tracks, animal trails, burrows and scat. Situate yourself in an area downwind from the trail and wait. Animals frequently use the same trails to approach watering holes and to reach meadows.

Approaching Wildlife

- Do not approach in a direct and purposeful manner. Parallel the animal and take a less direct route. Avoid looking at the animal and making direct eye contact.

- Stay in the animal's sight after it has seen you. Walk slowly and quietly. Pause often. Take a picture of the animal when you first see it in case you never get the opportunity to photograph it again.

- **Do not get too close to an animal, especially a female with young. Respect their territory for their safety and yours.**